UNTAMEDDESIGNS

COLORING BOOK

ARKADY ROYTMAN

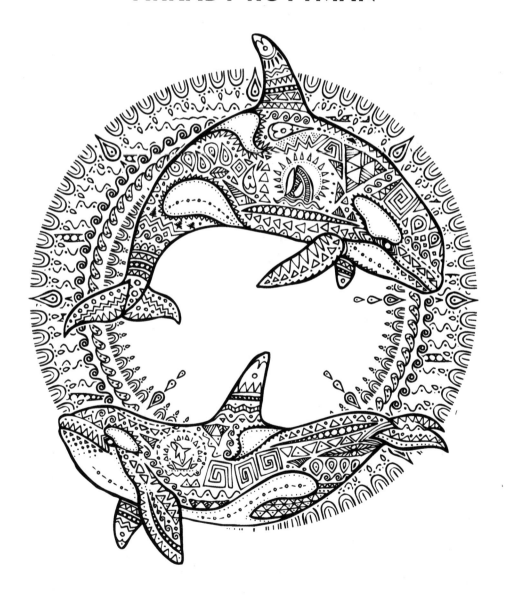

DOVER PUBLICATIONS, INC.
MINEOLA, NEW YORK

This coloring book features thirty-one intricate images of wild animals, rendered in the artistic style of the Inuit people of the Arctic. They feature dazzling backgrounds along with geometric motifs that will challenge colorists of all skill levels. In addition, the pages are perforated and are printed on one side only for easy removal and display.

Bibliographical Note

Untamed Designs Coloring Book is a new work, first published
by Dover Publications, Inc., in 2016.

International Standard Book Number

ISBN-13: 978-0-486-80759-1
ISBN-10: 0-486-80759-2

Manufactured in the United States by RR Donnelley
80759201 2016
www.doverpublications.com

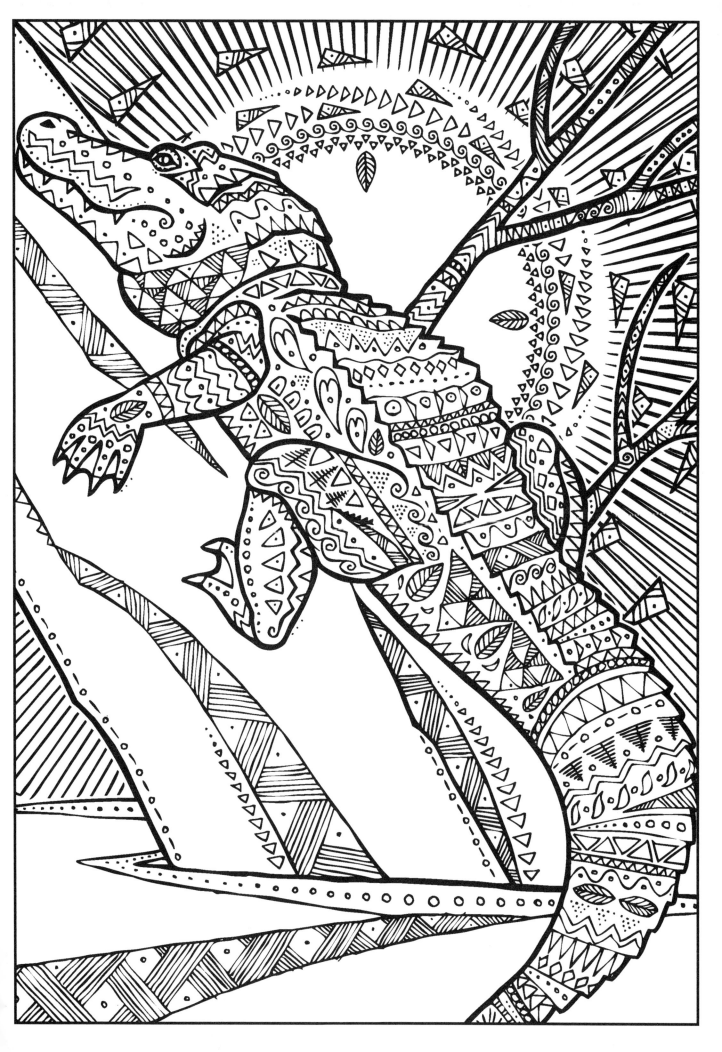

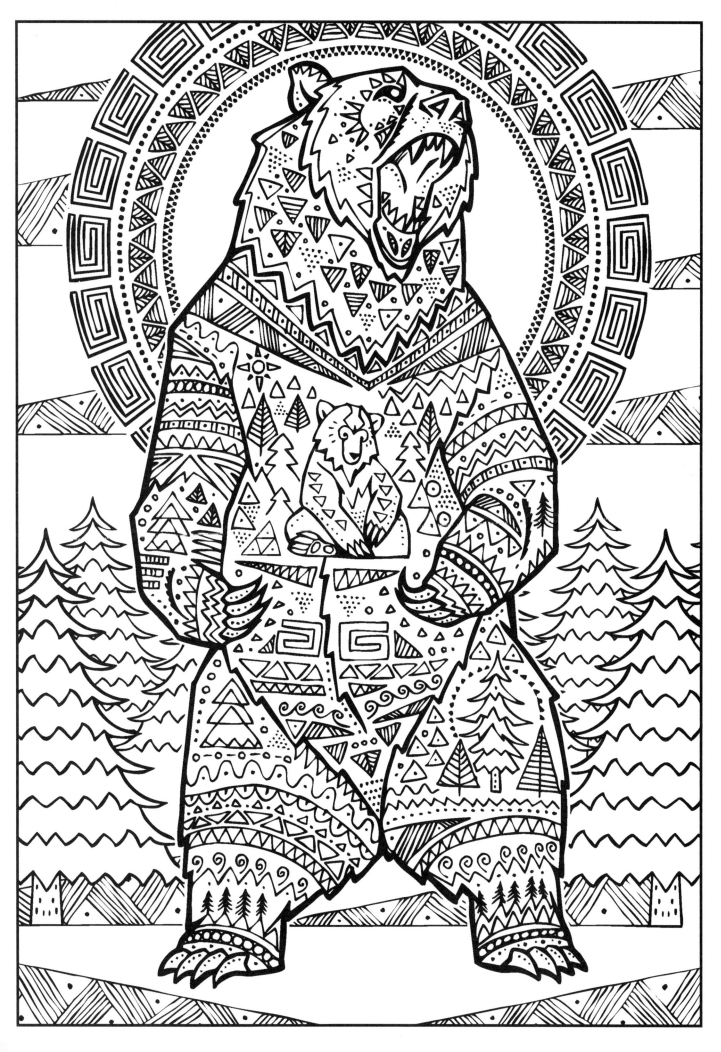

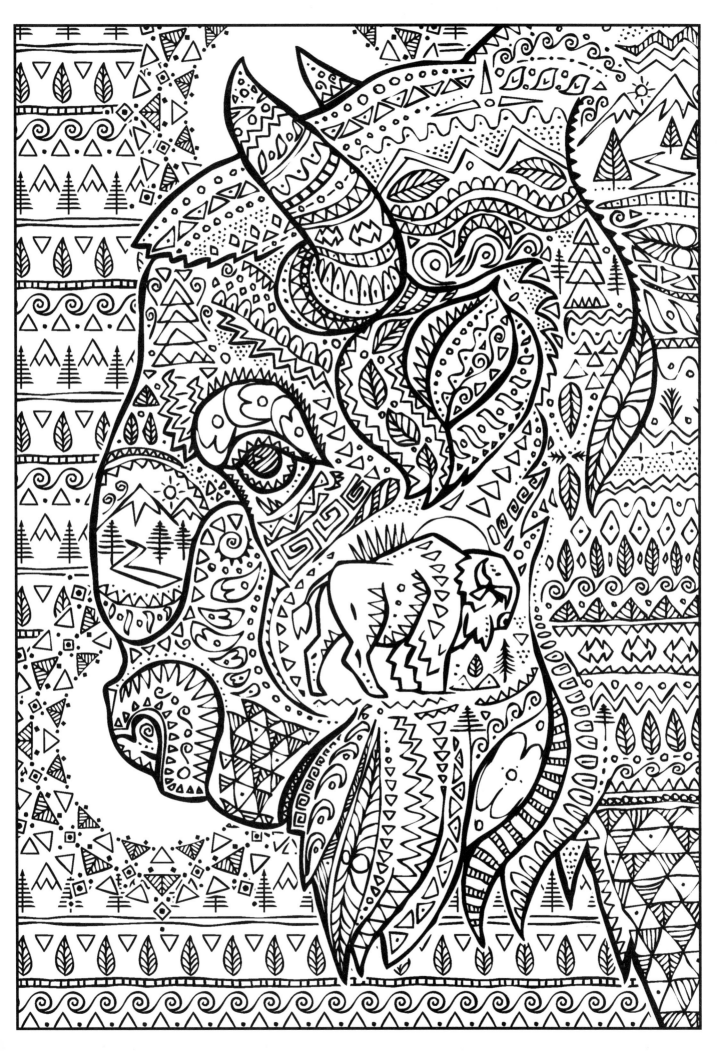

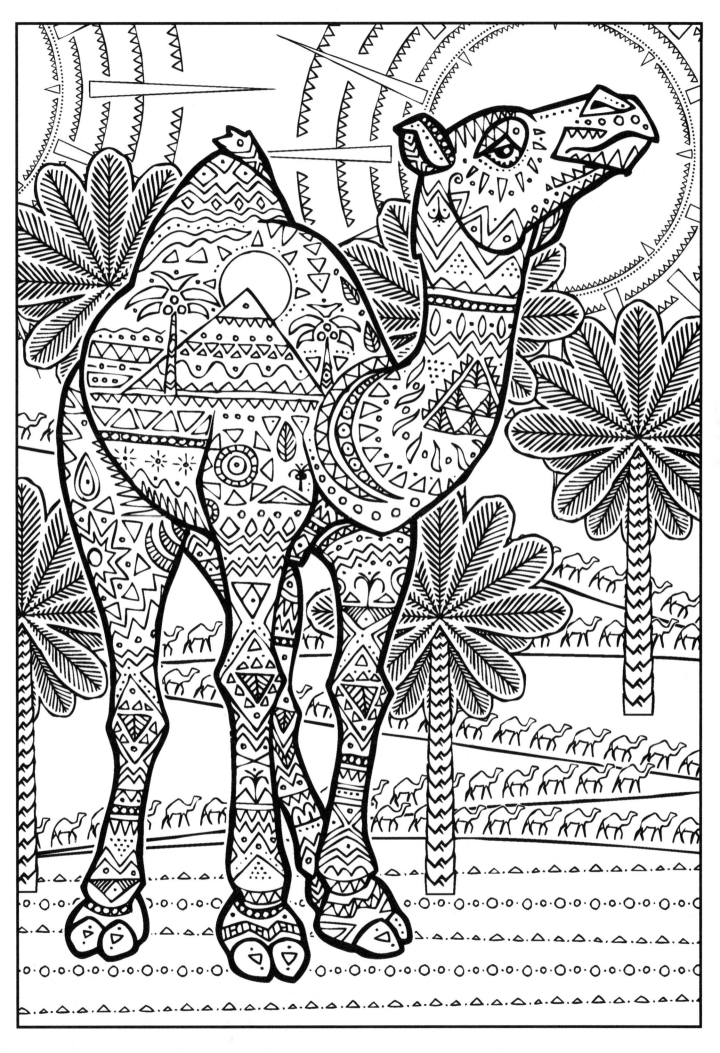

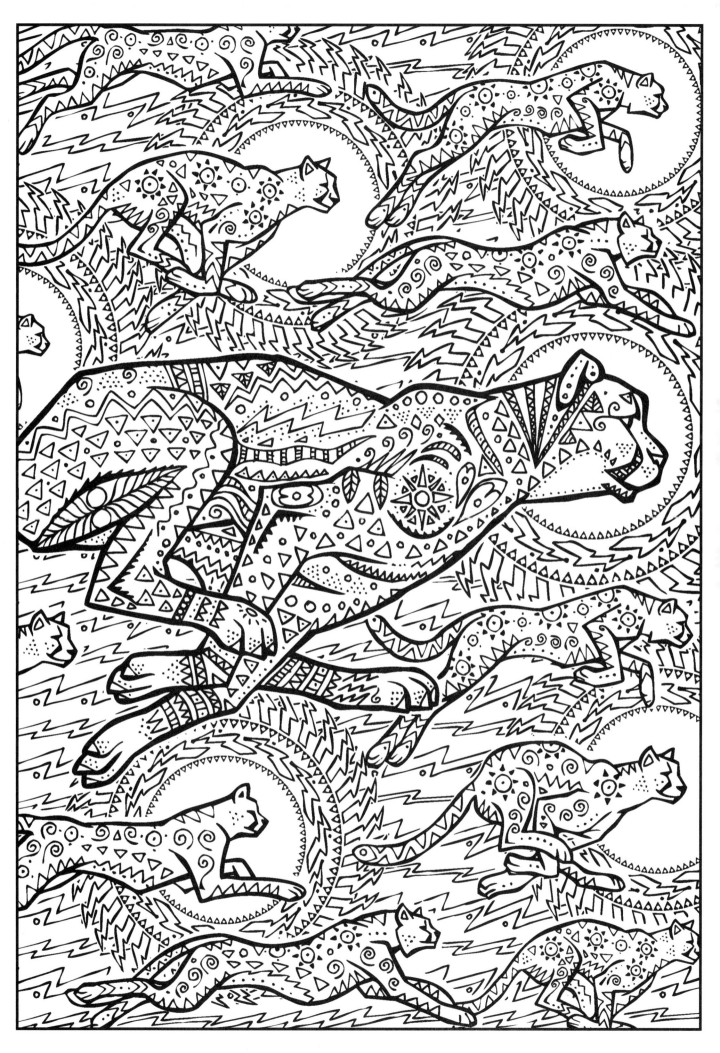

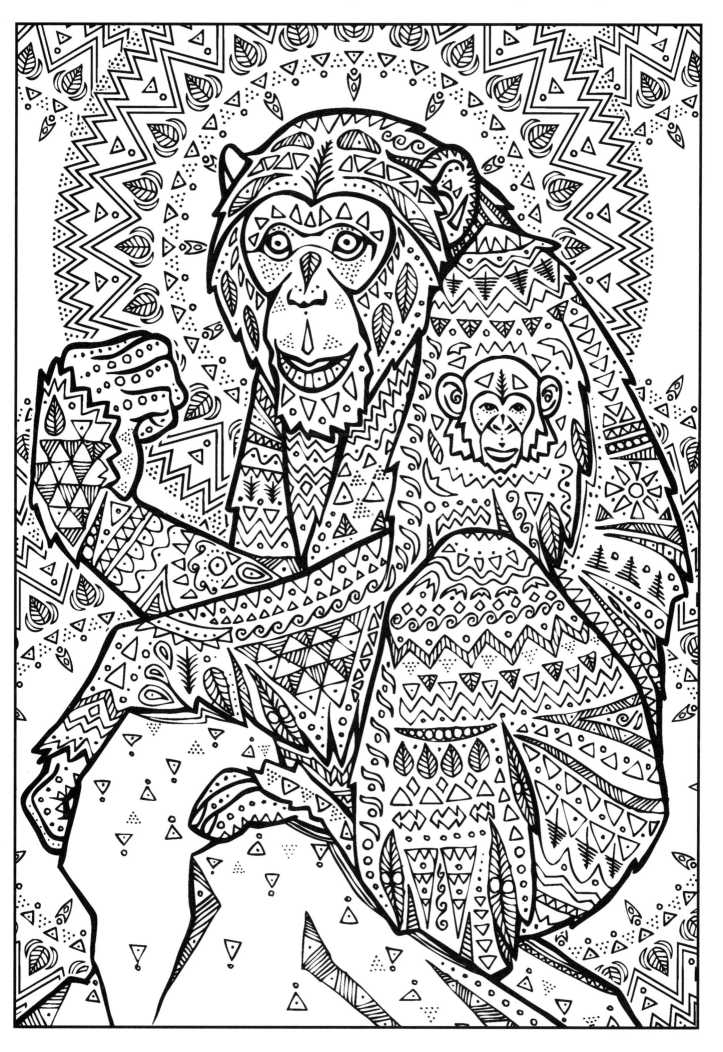

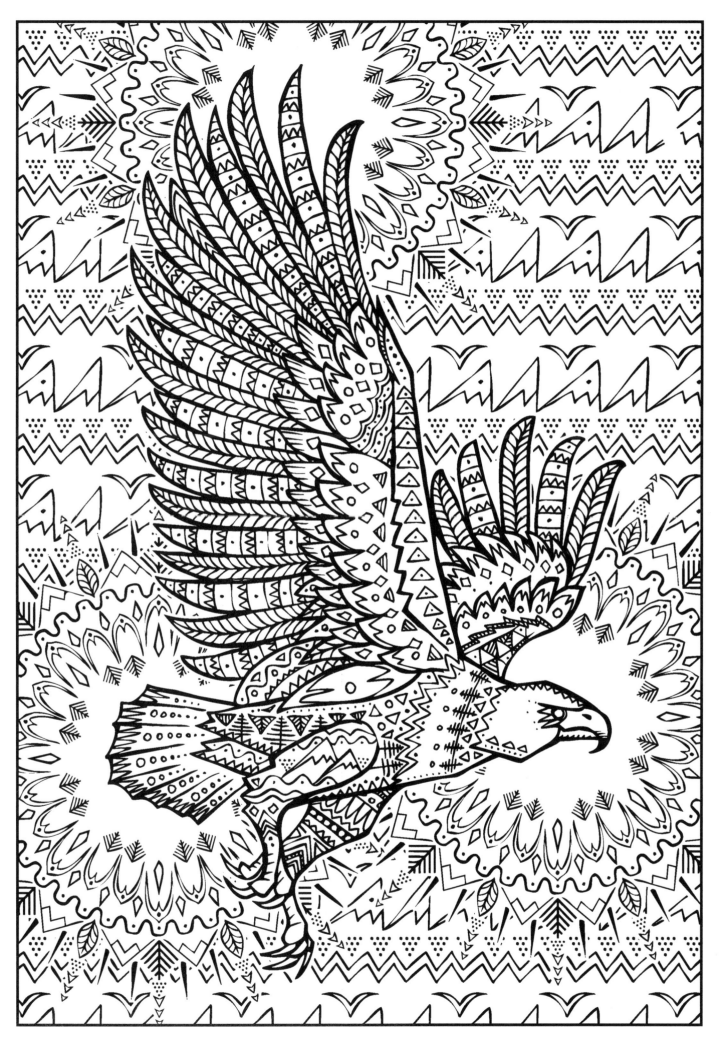

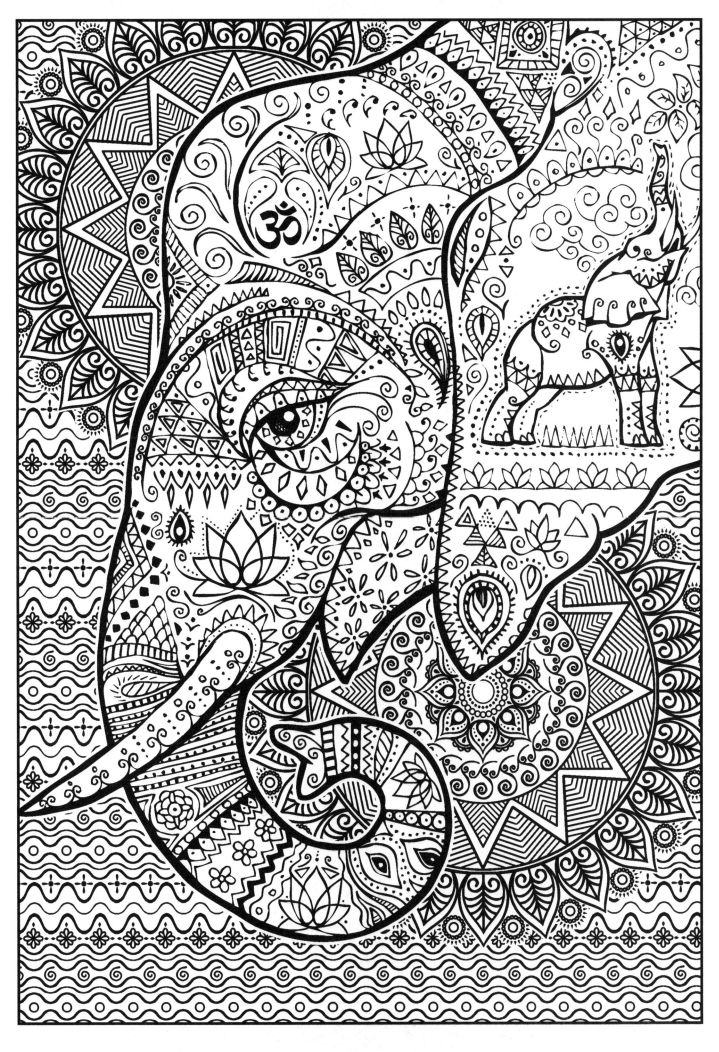

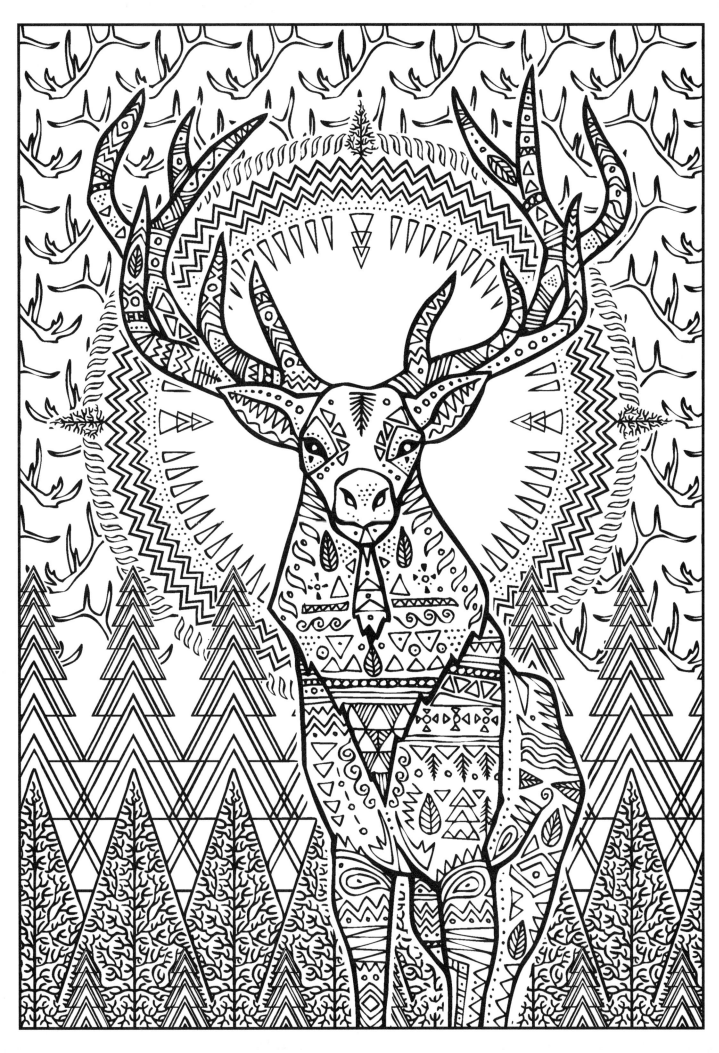

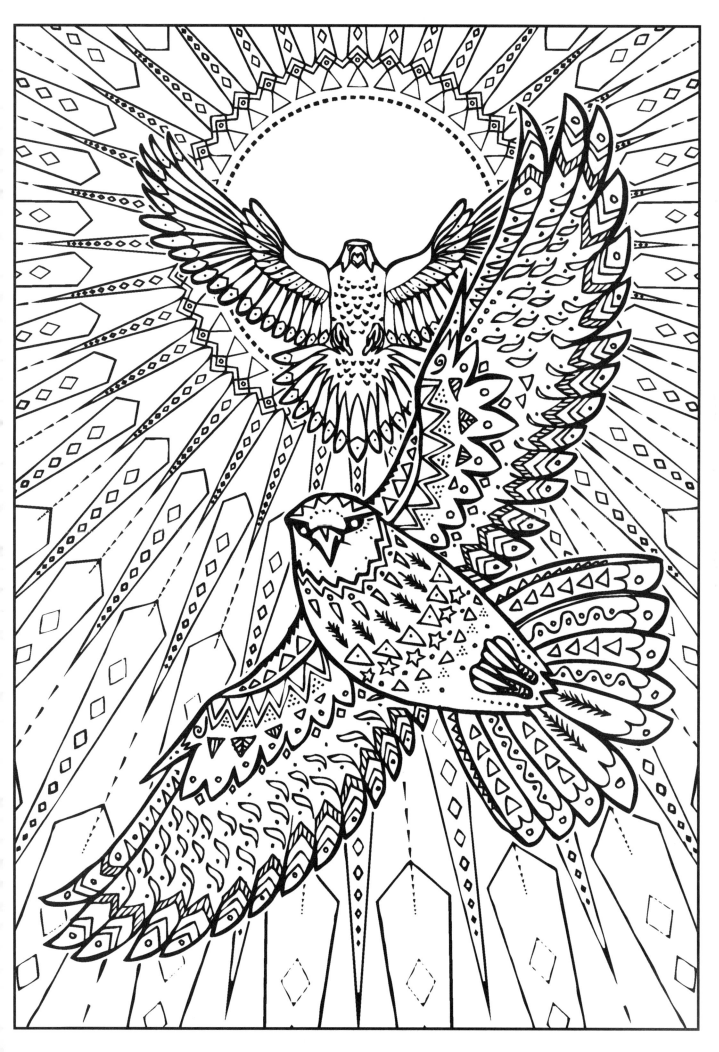

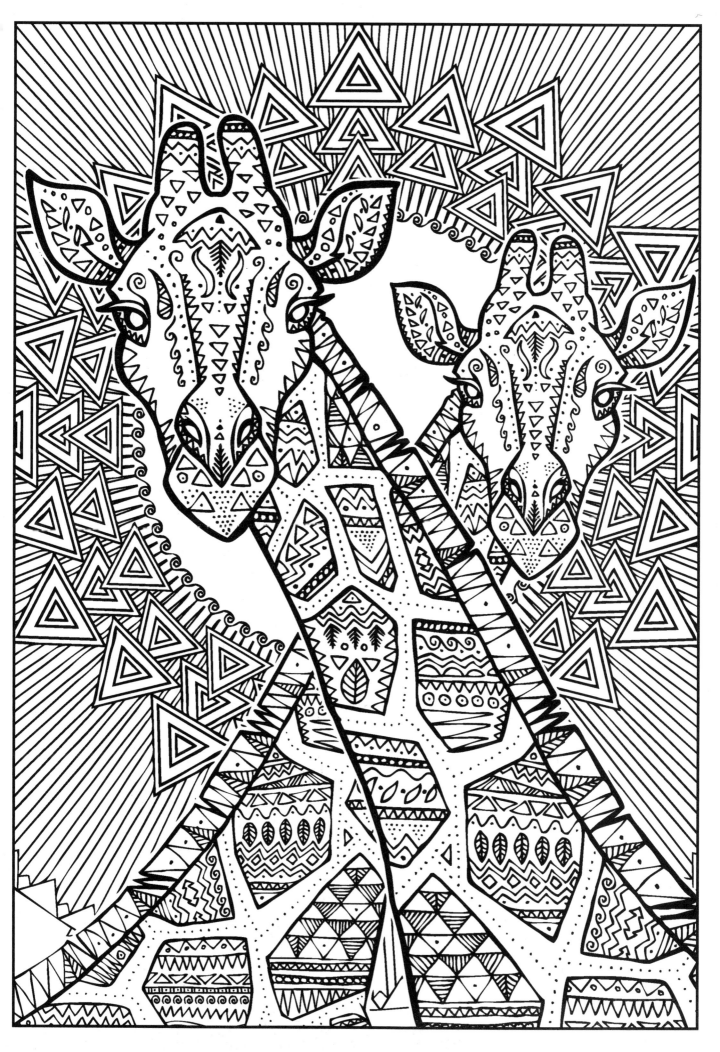

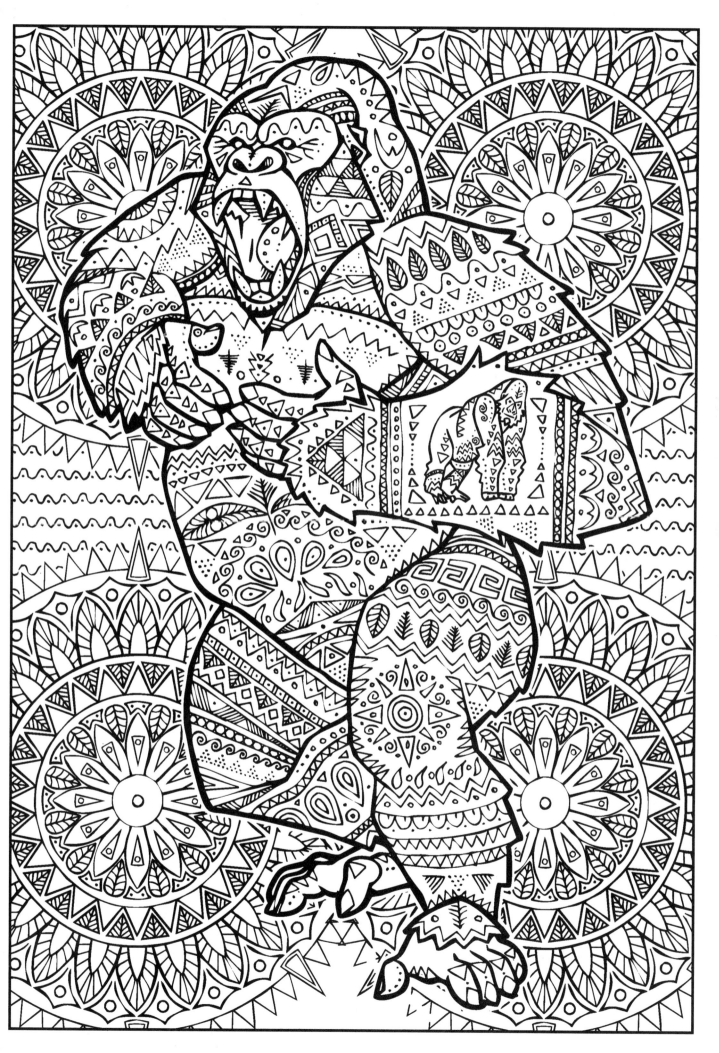

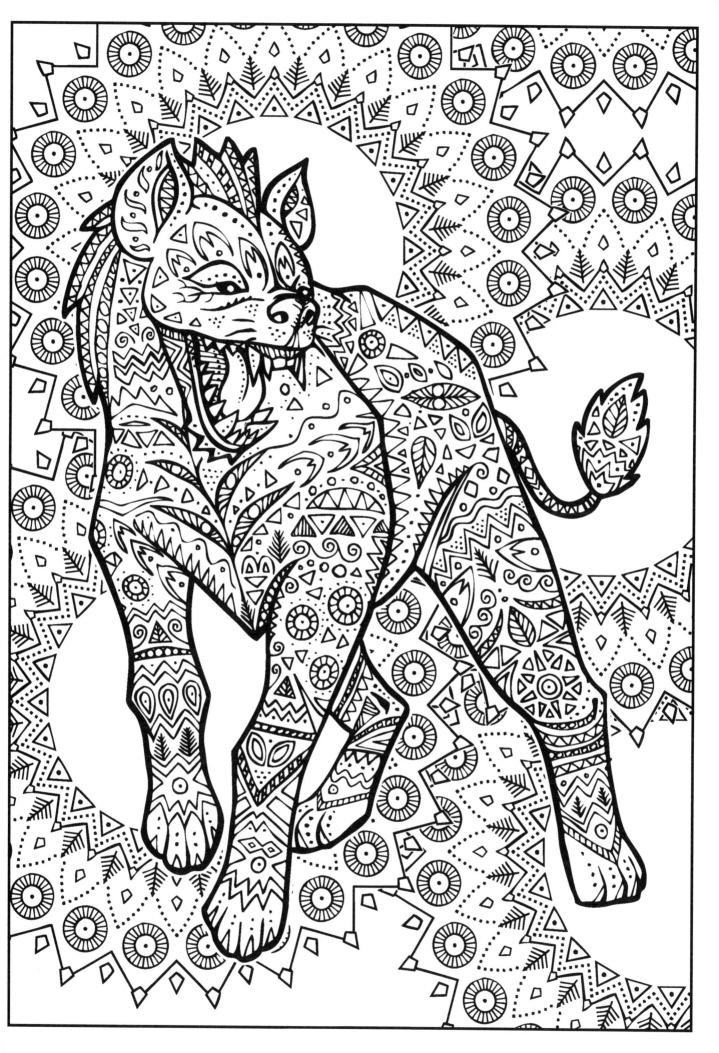

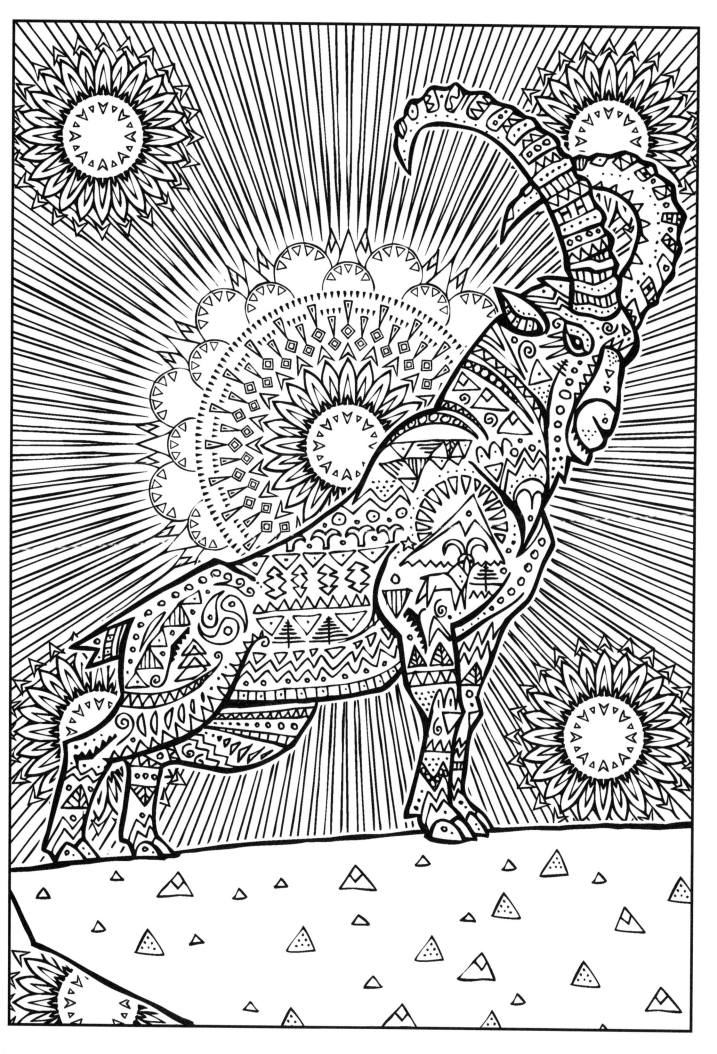

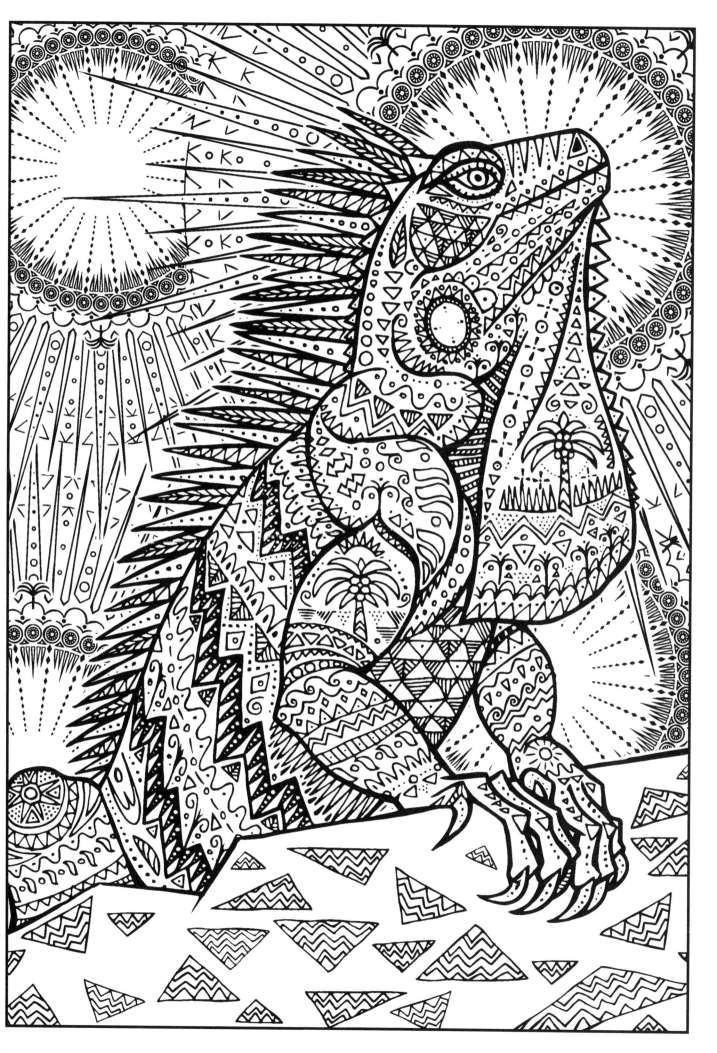

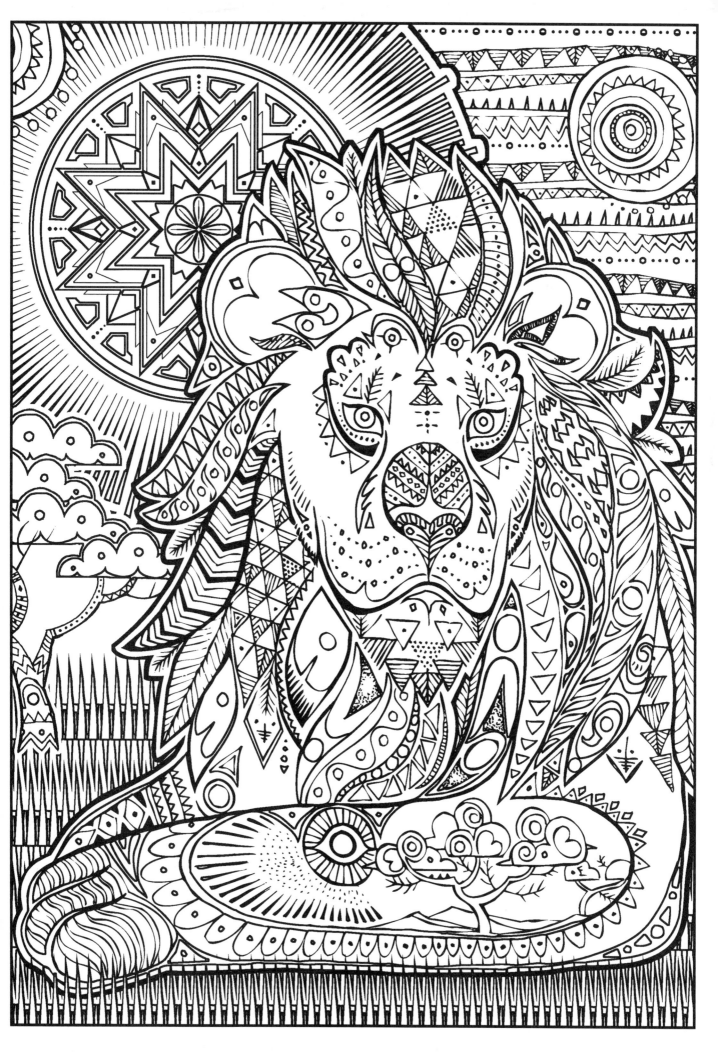

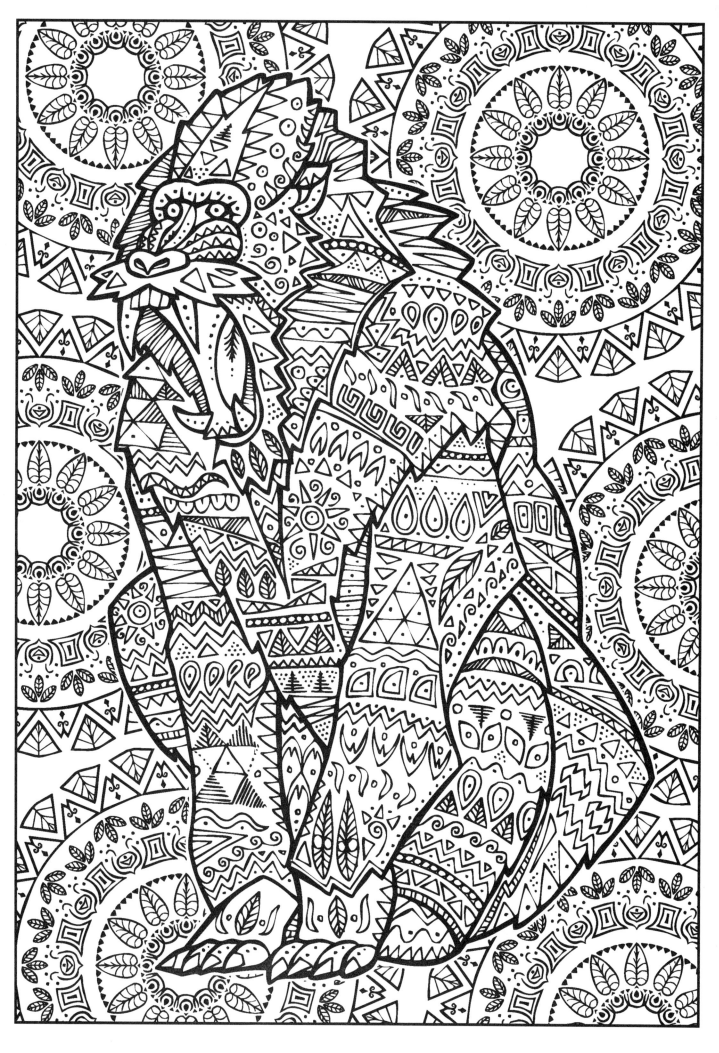

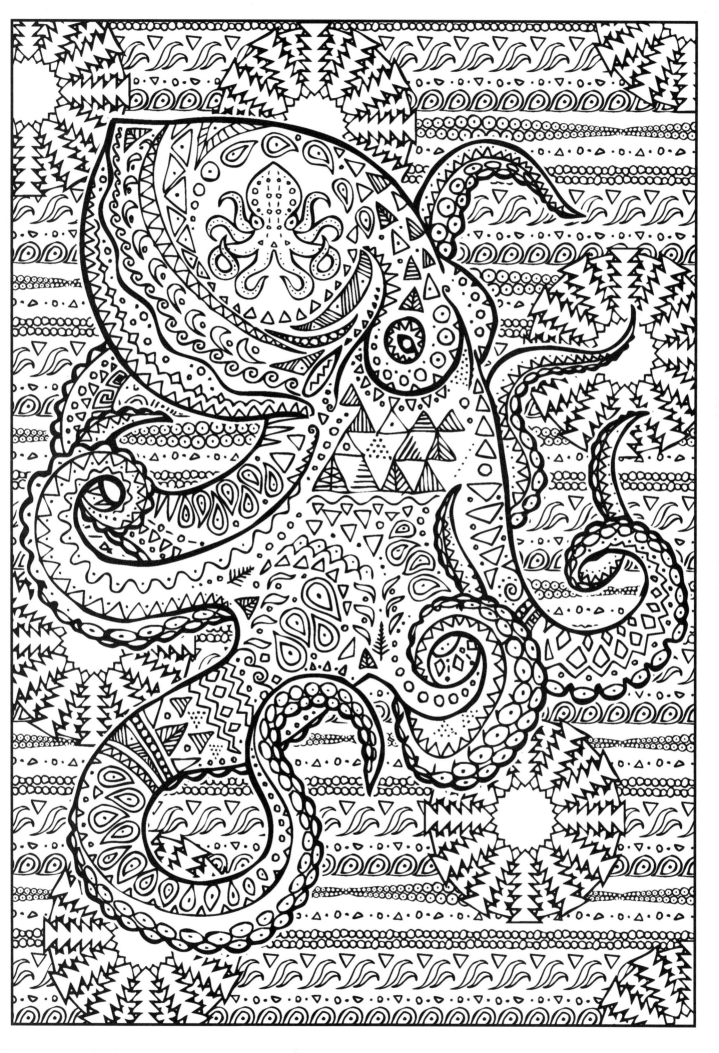

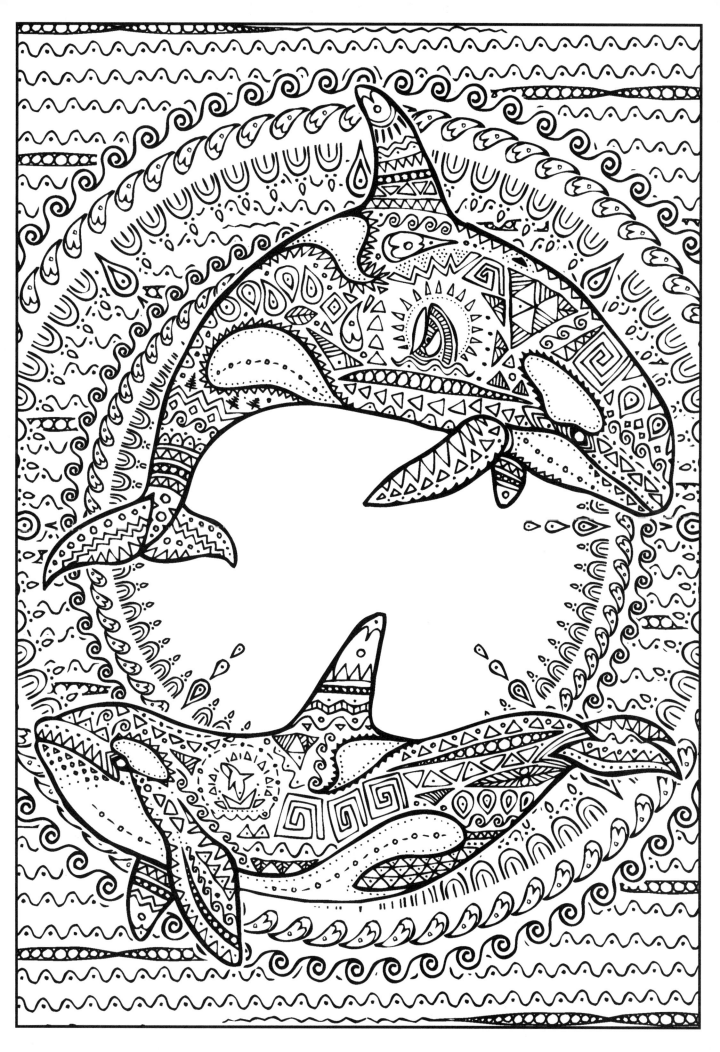

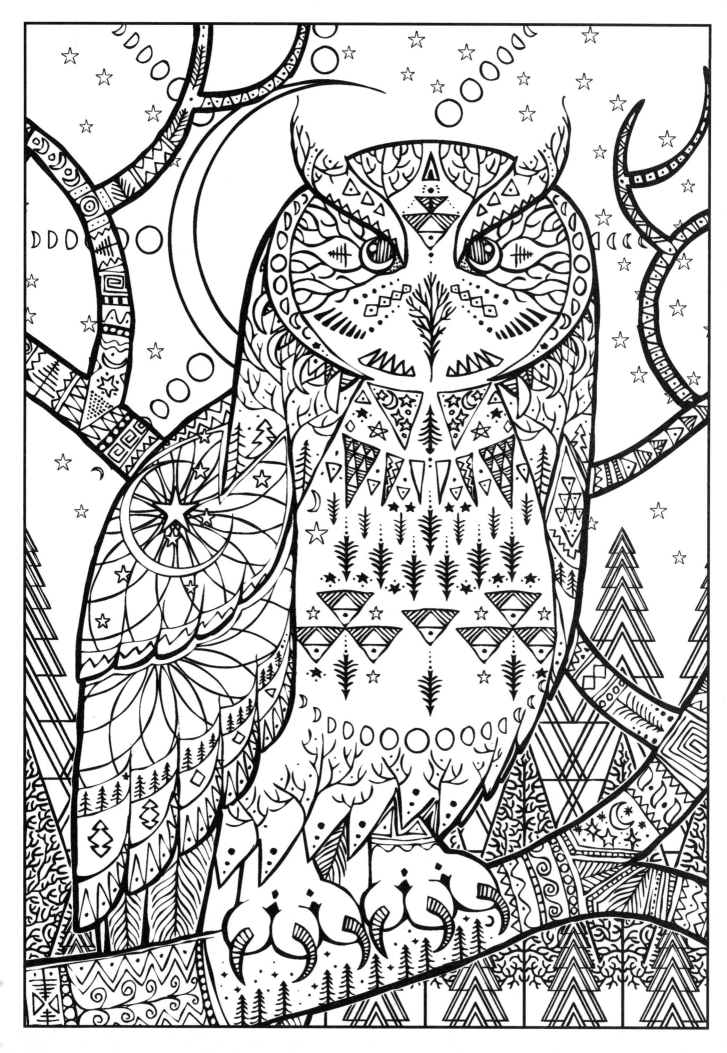

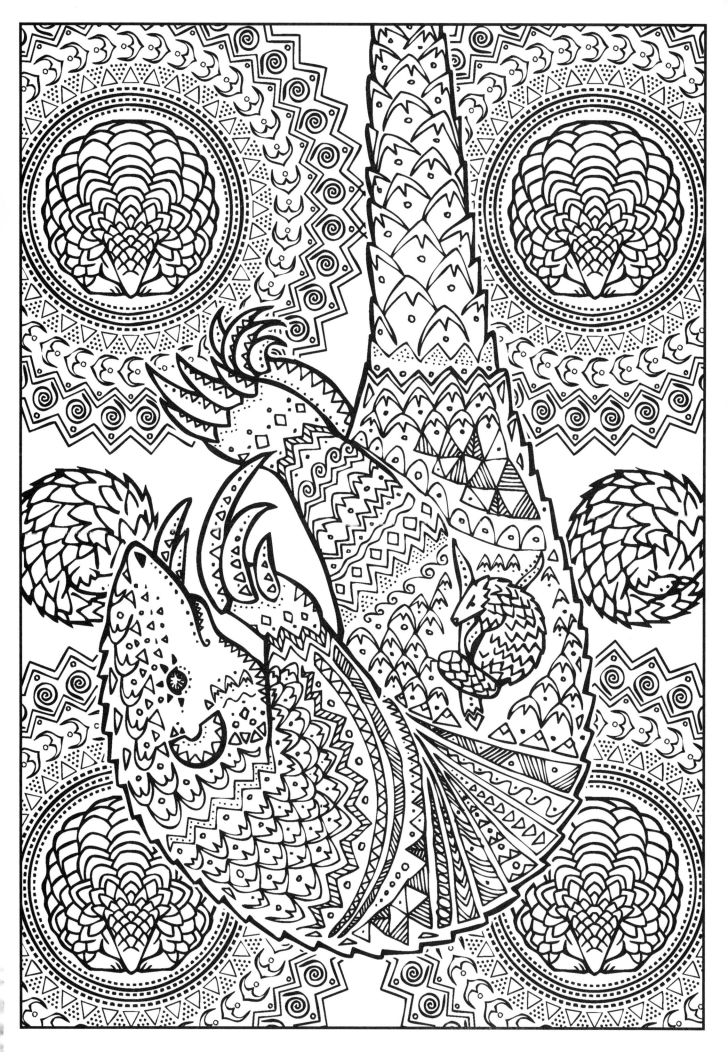

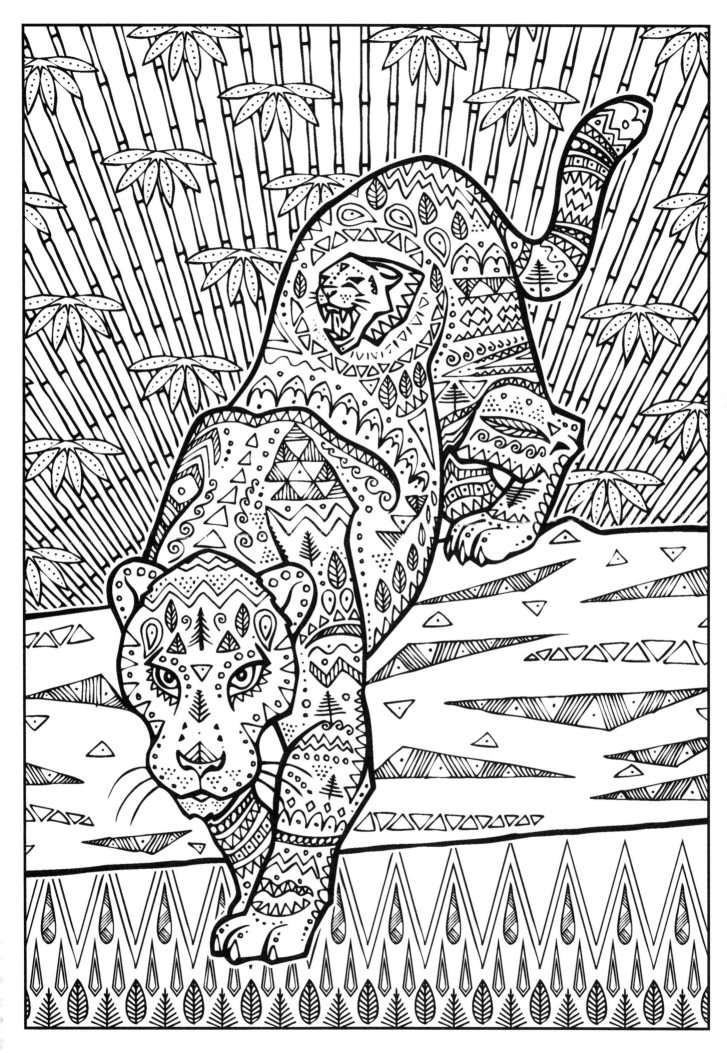

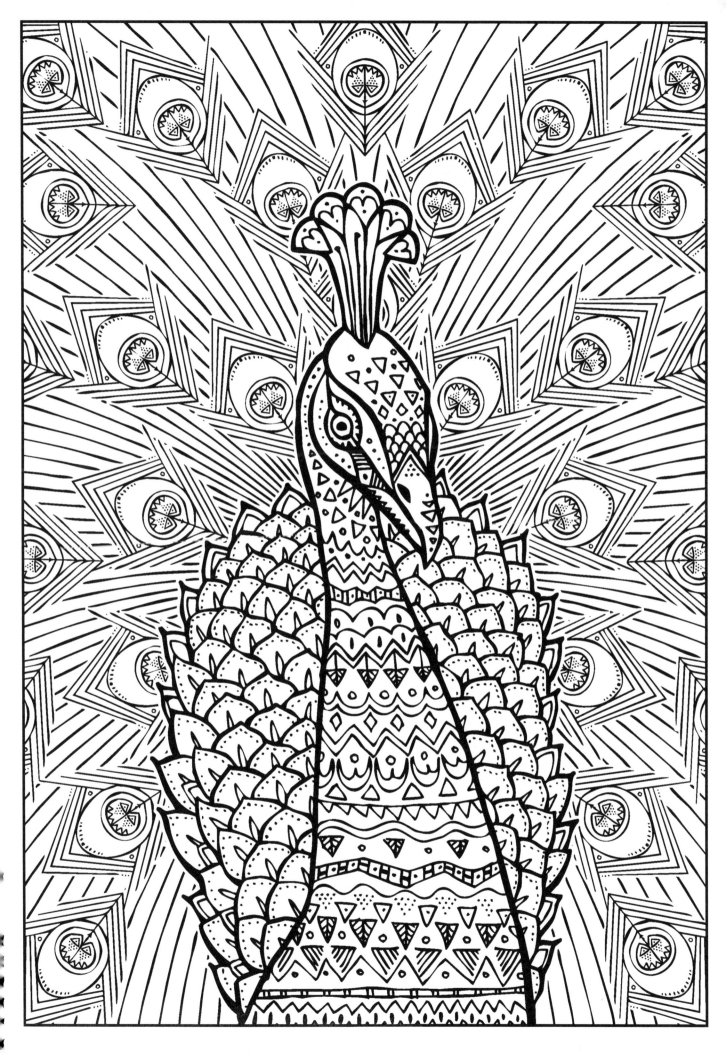

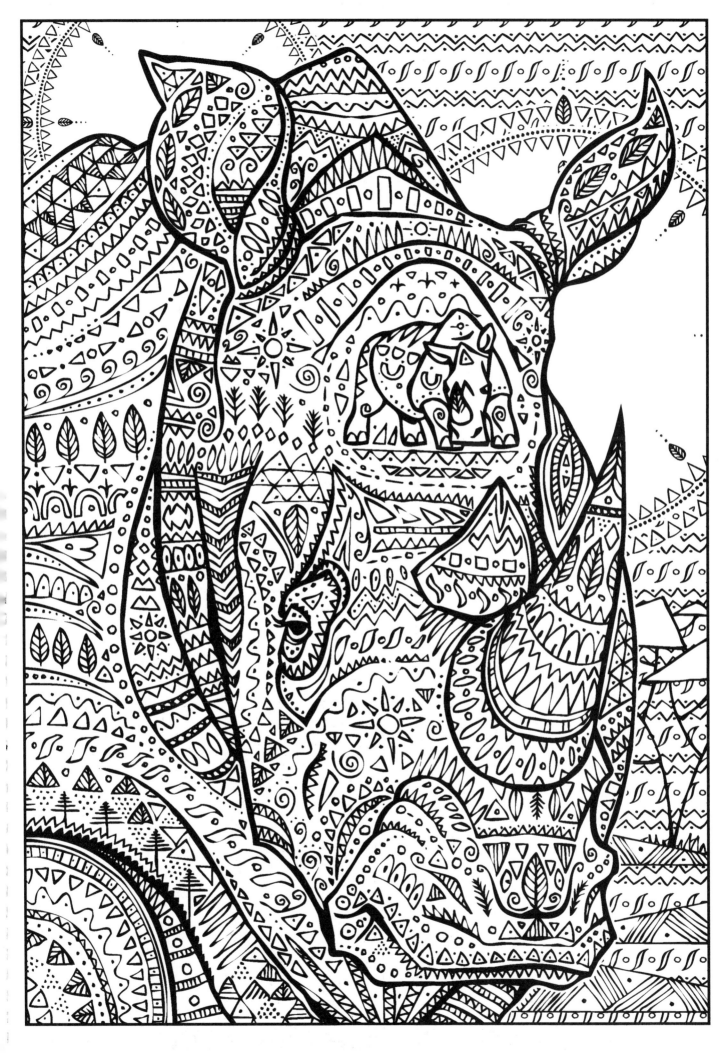

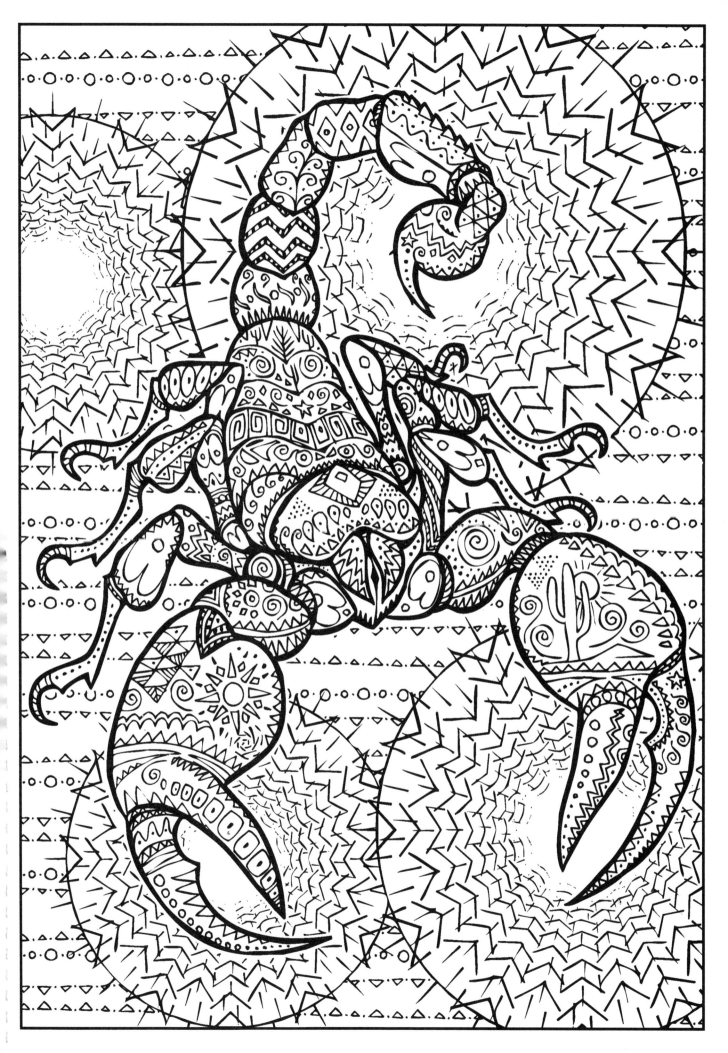

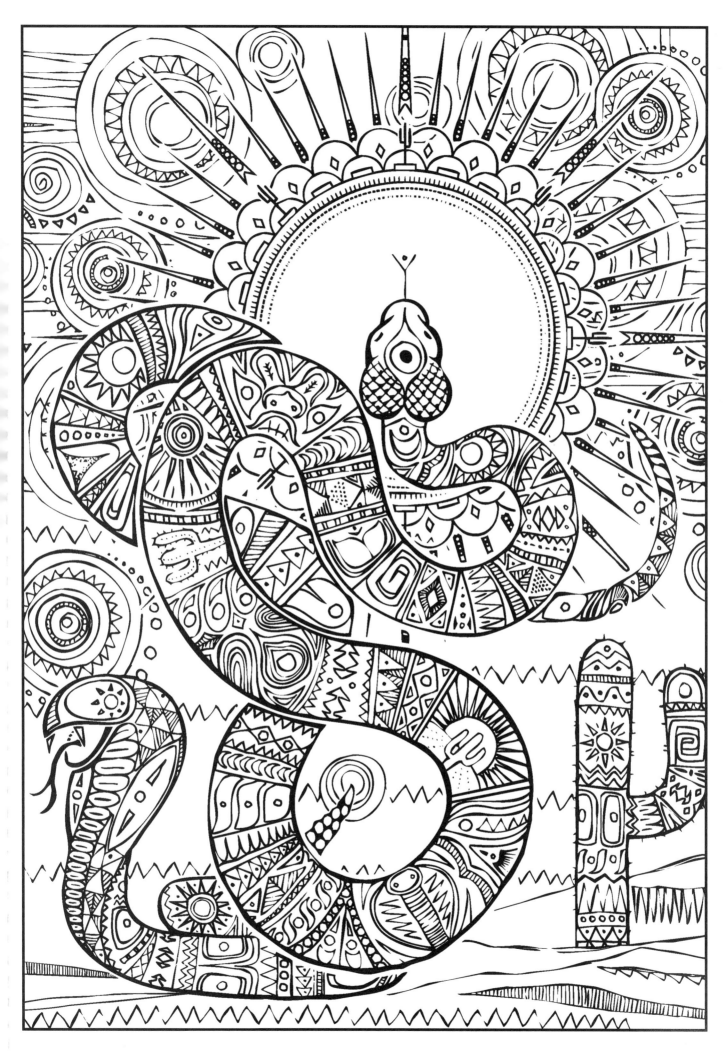

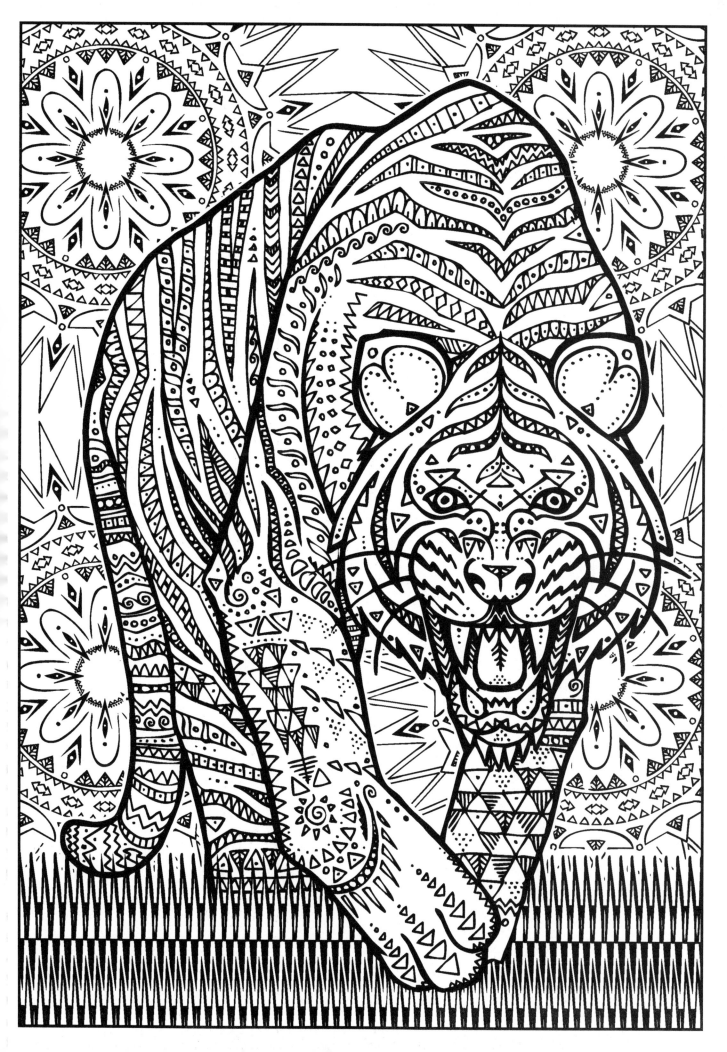

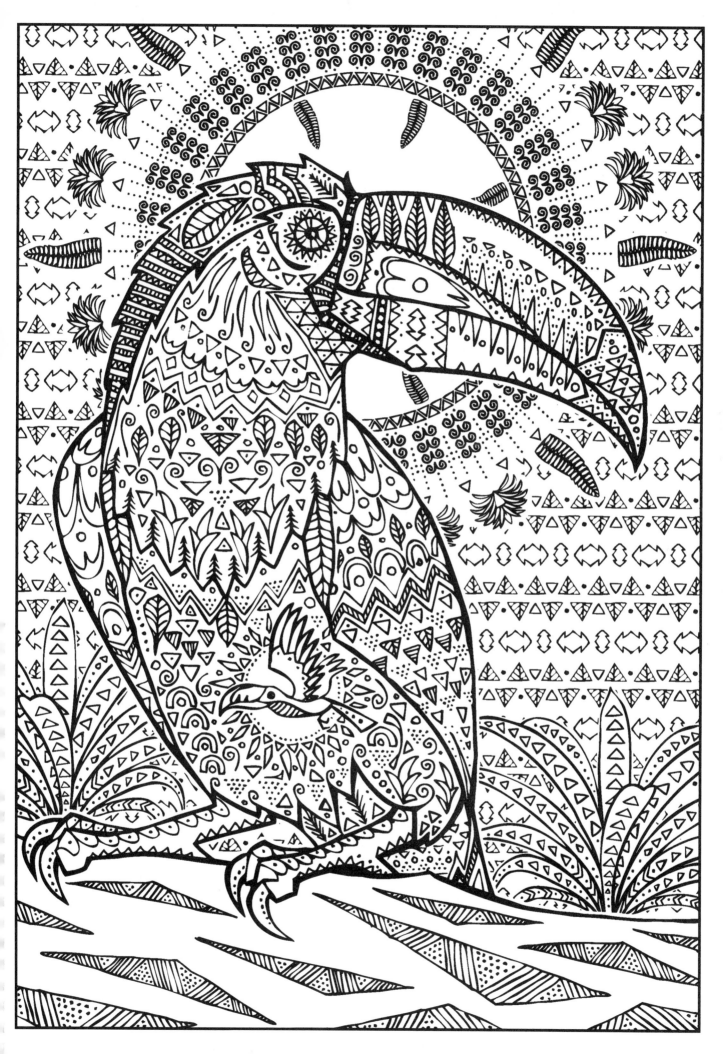

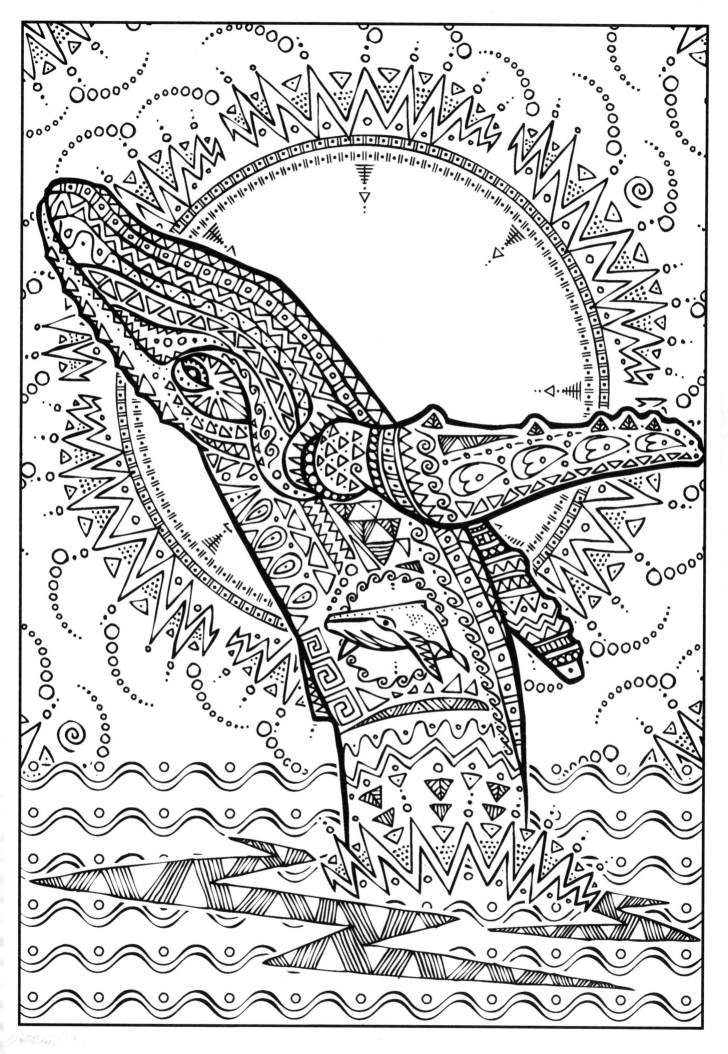

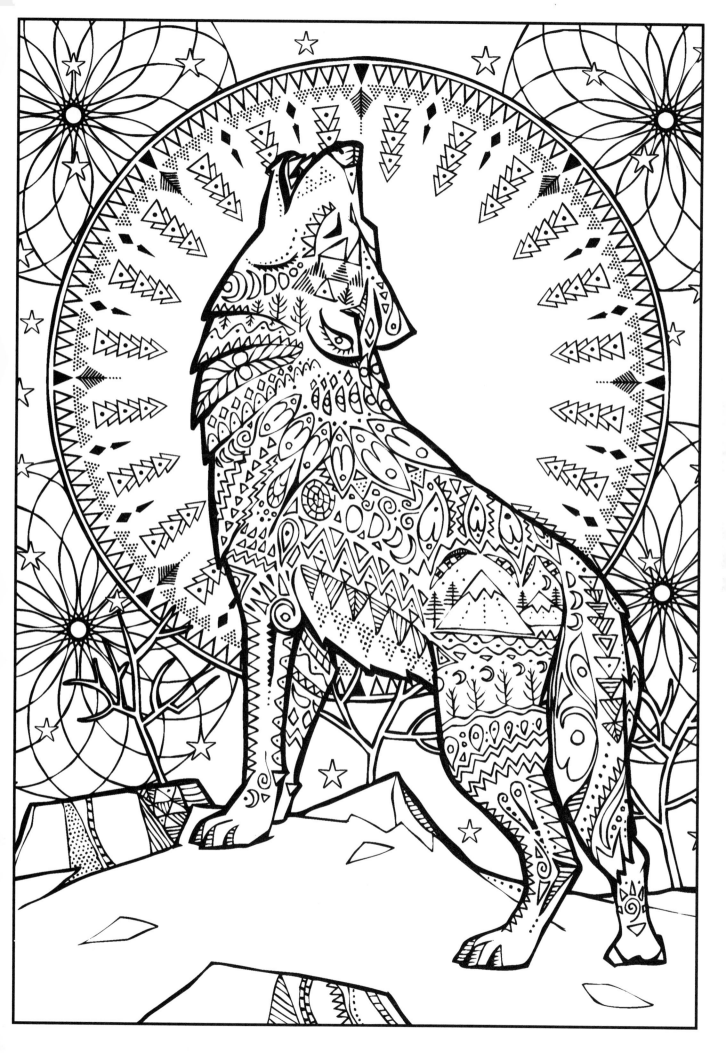

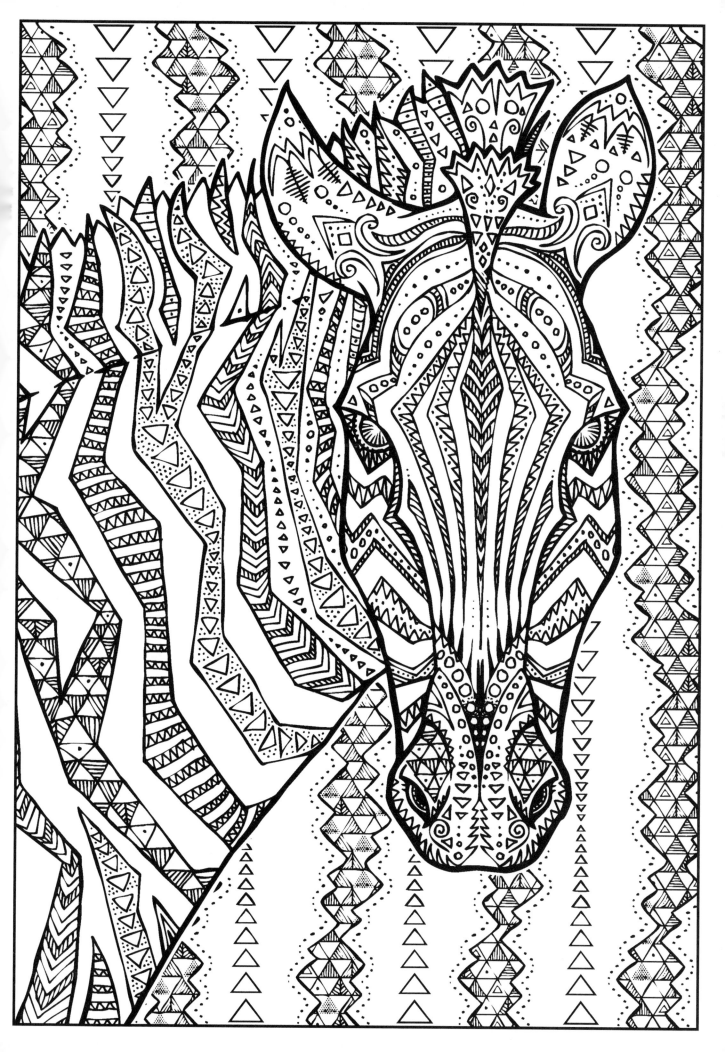